HELLO

Welcome to the whimsical world of Kosharek Art, where bright colors and kindess rule! Hope is queen and street art for the masses makes a gallery for all to enjoy! ♥

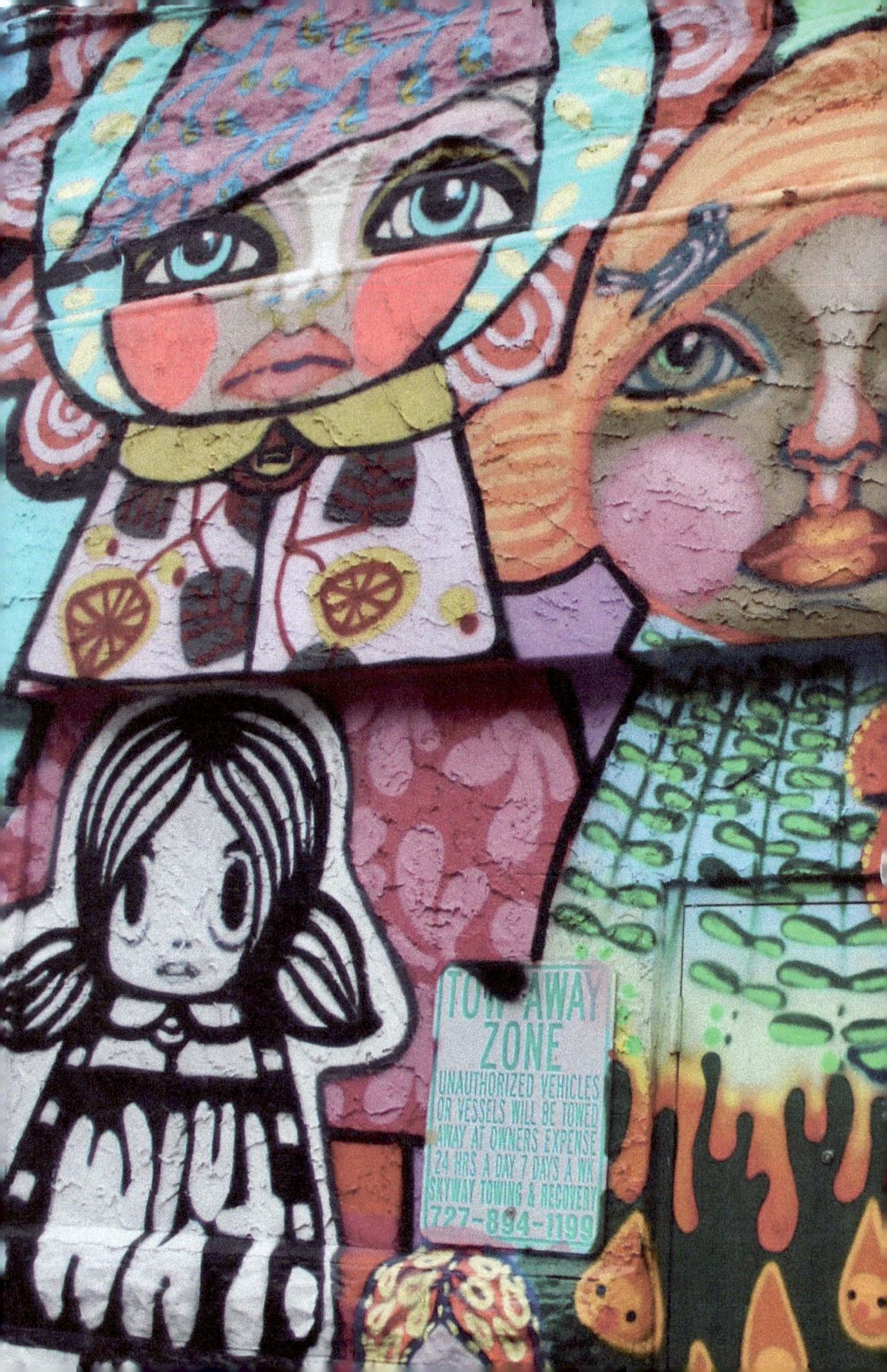

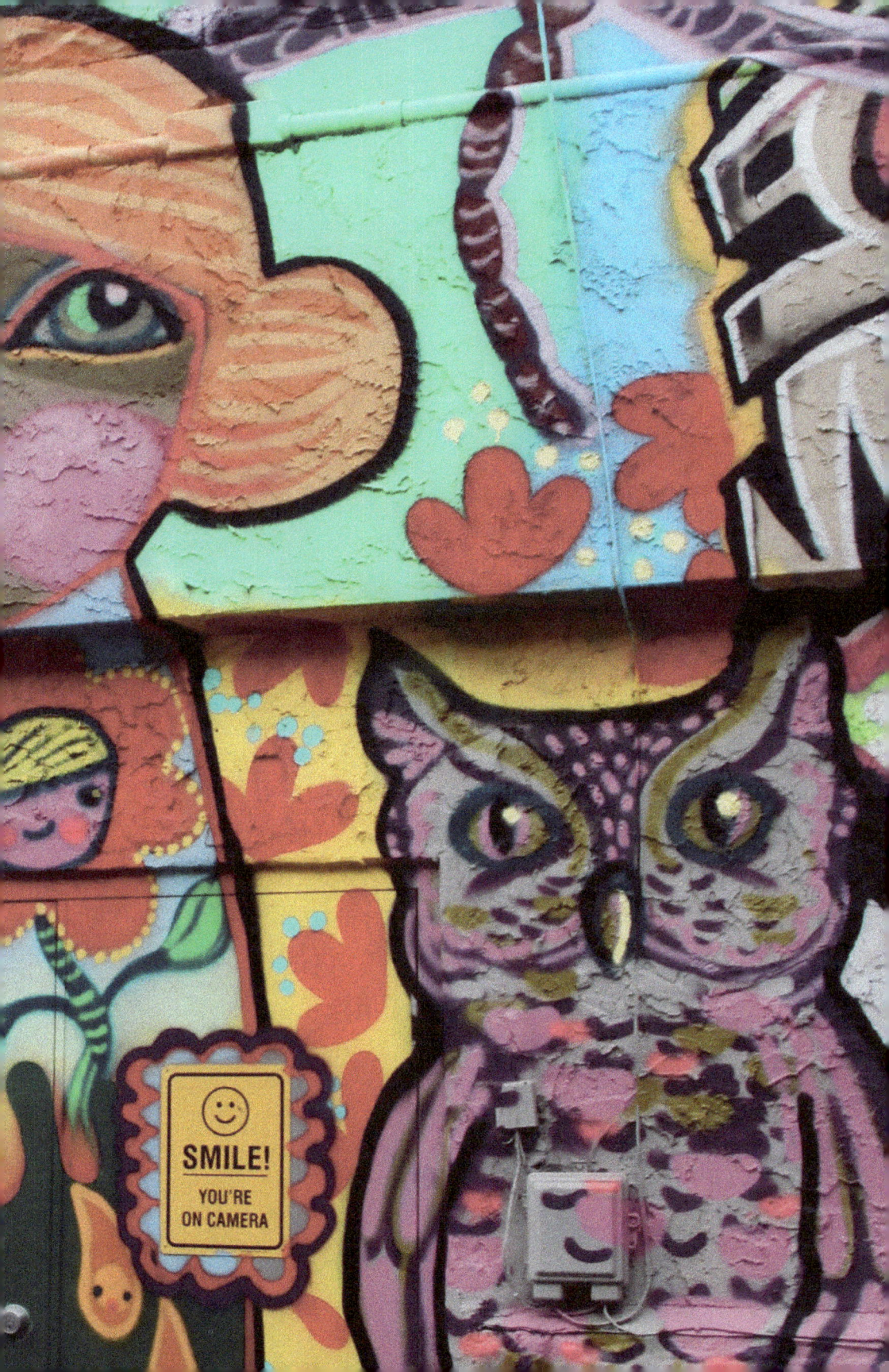

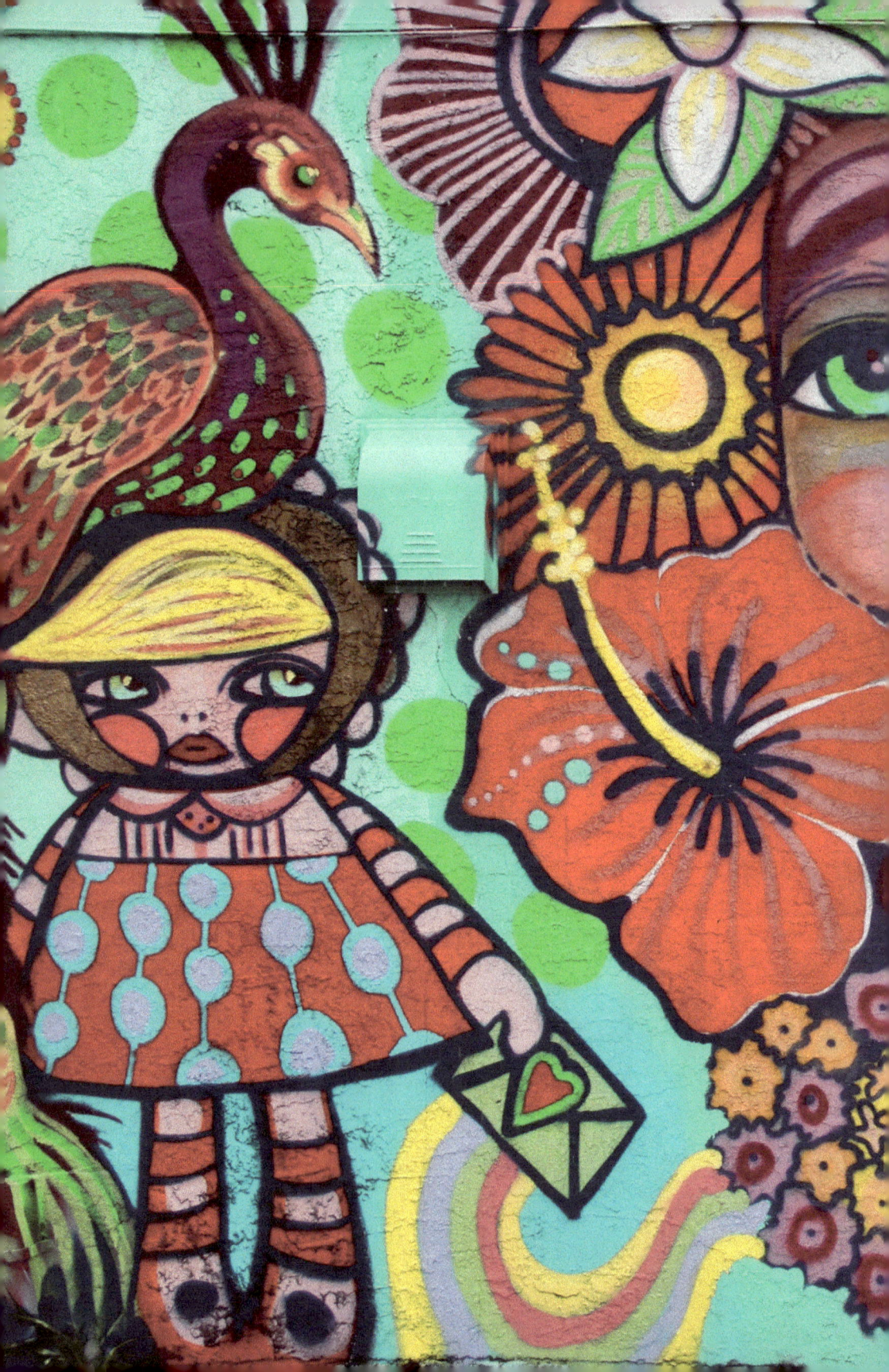

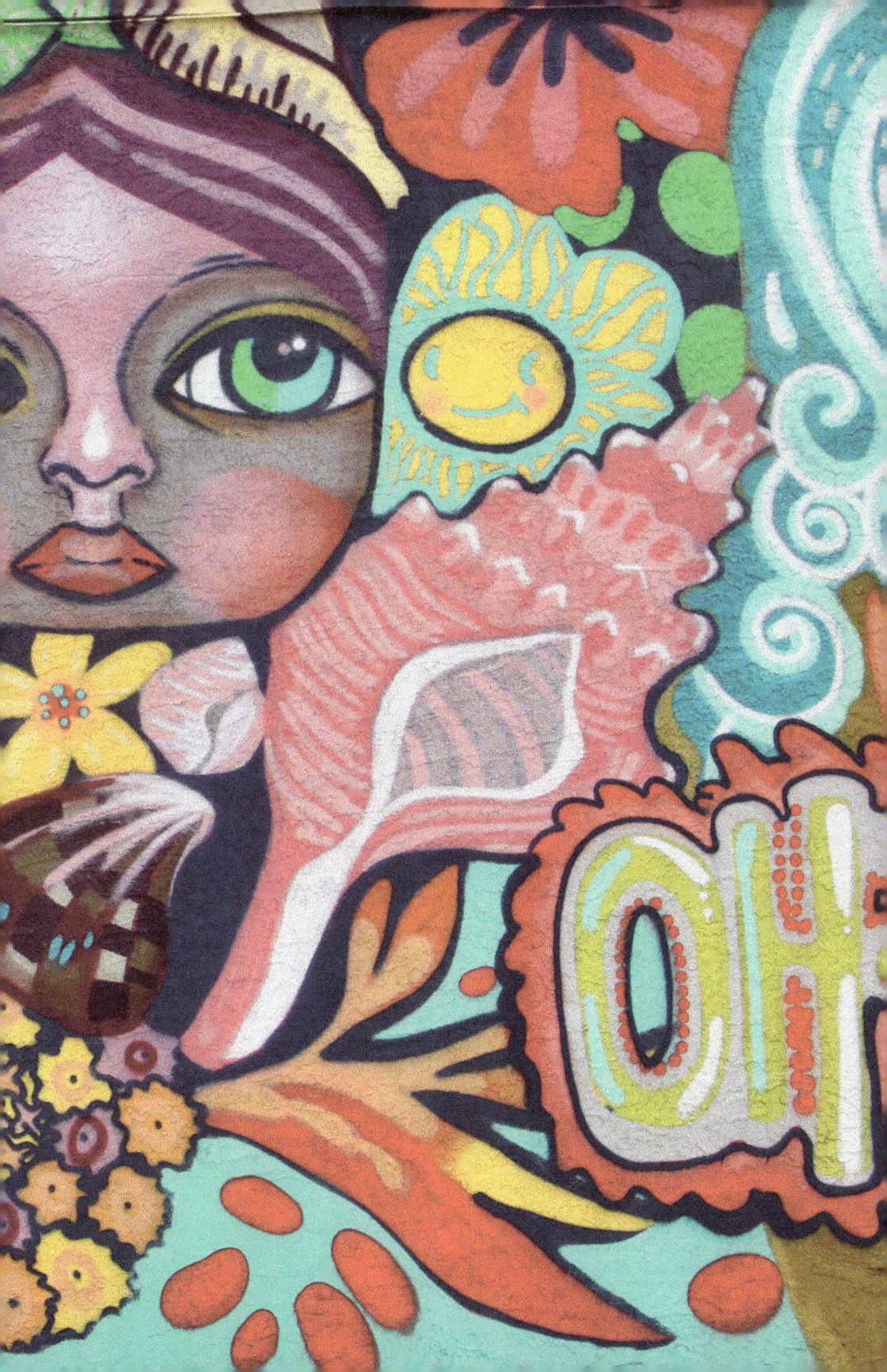

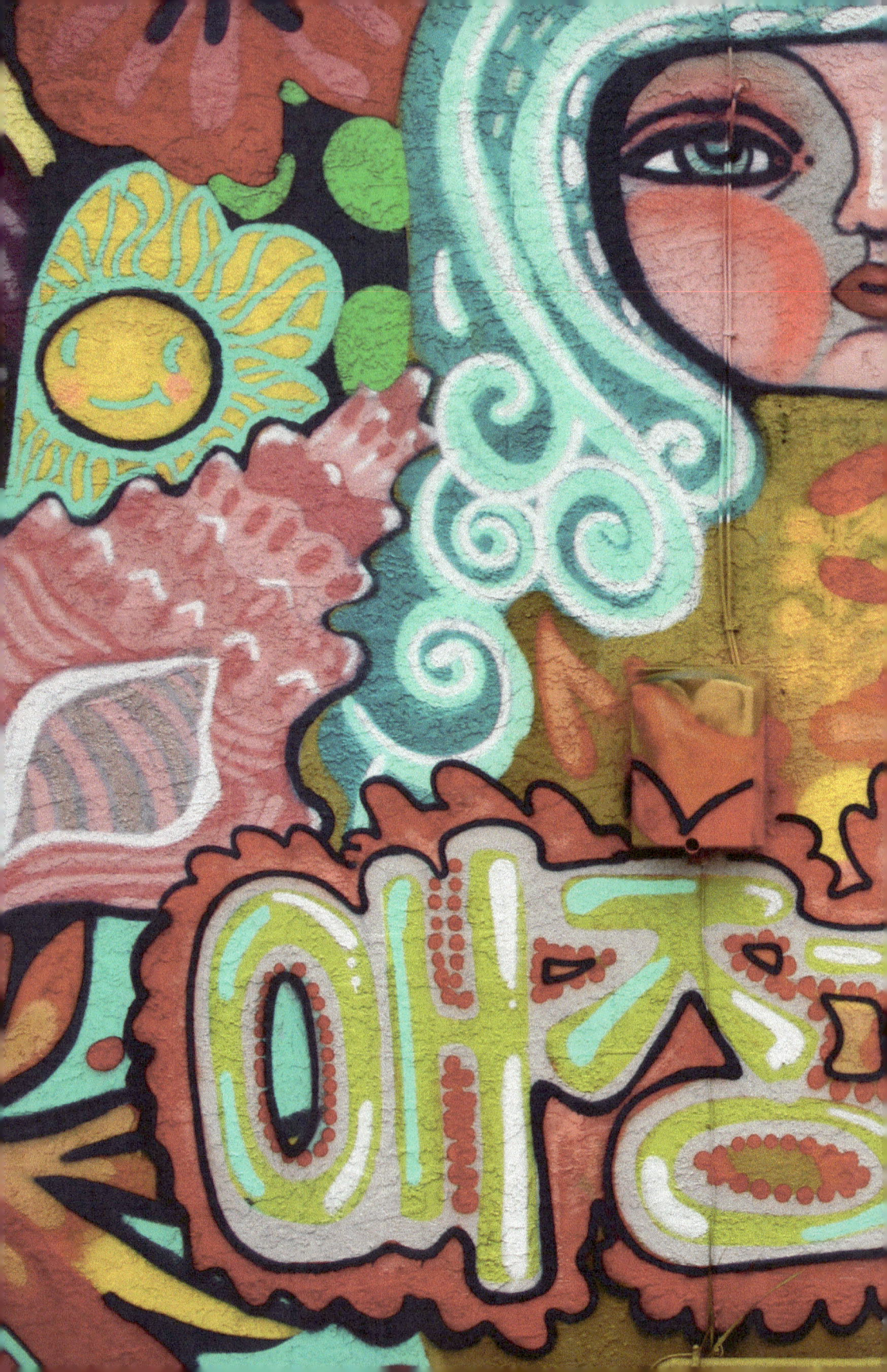

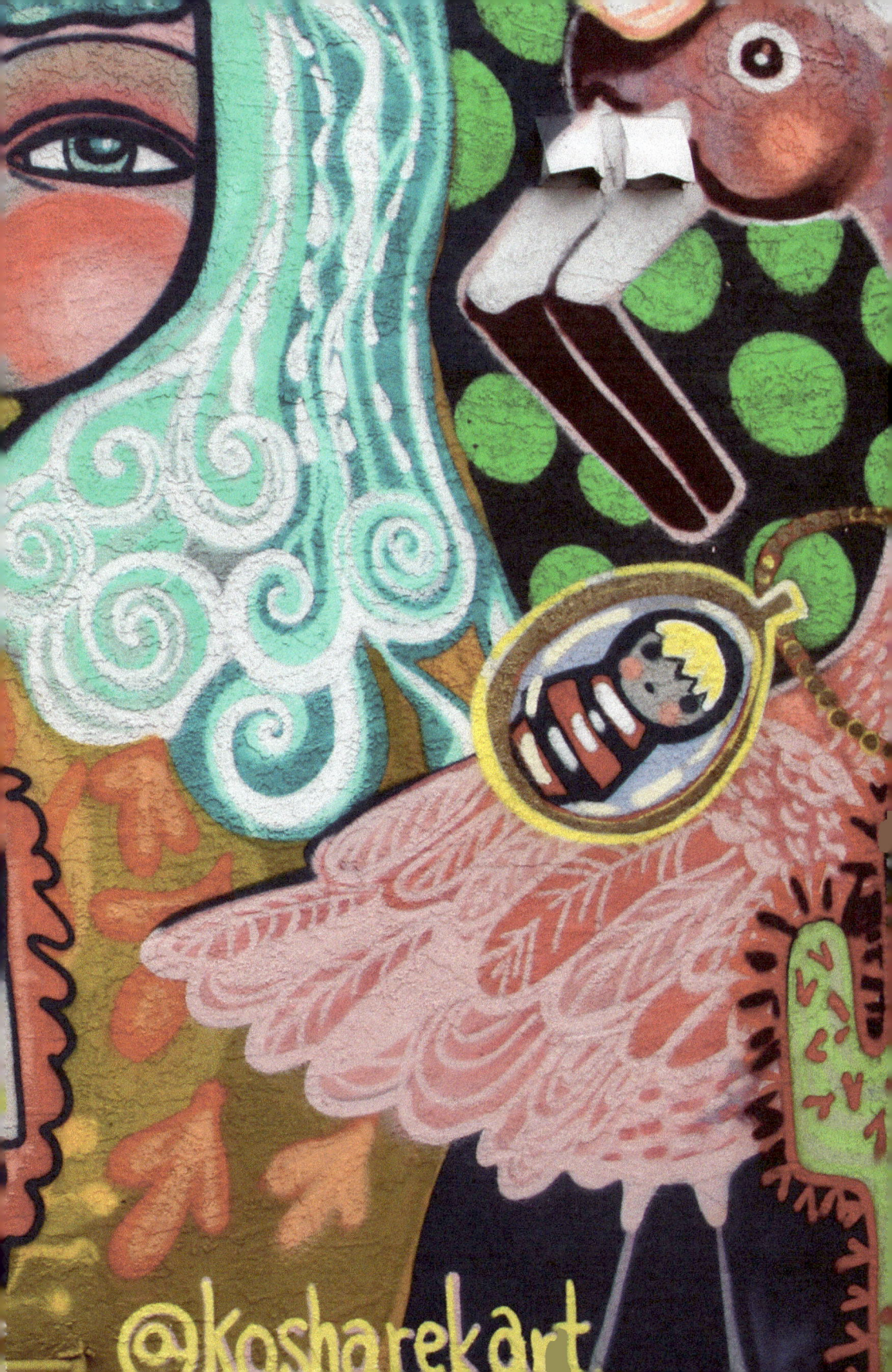

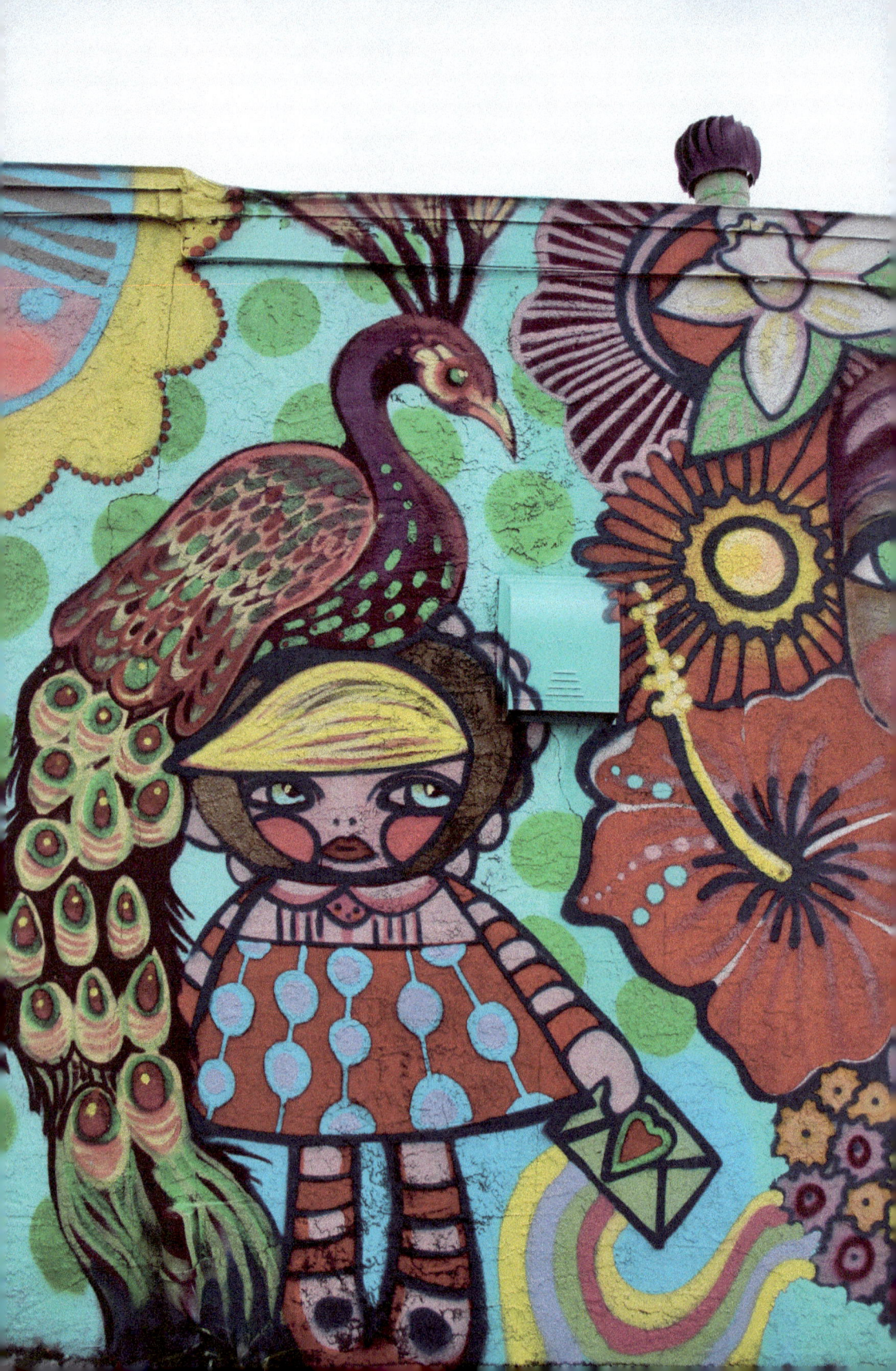

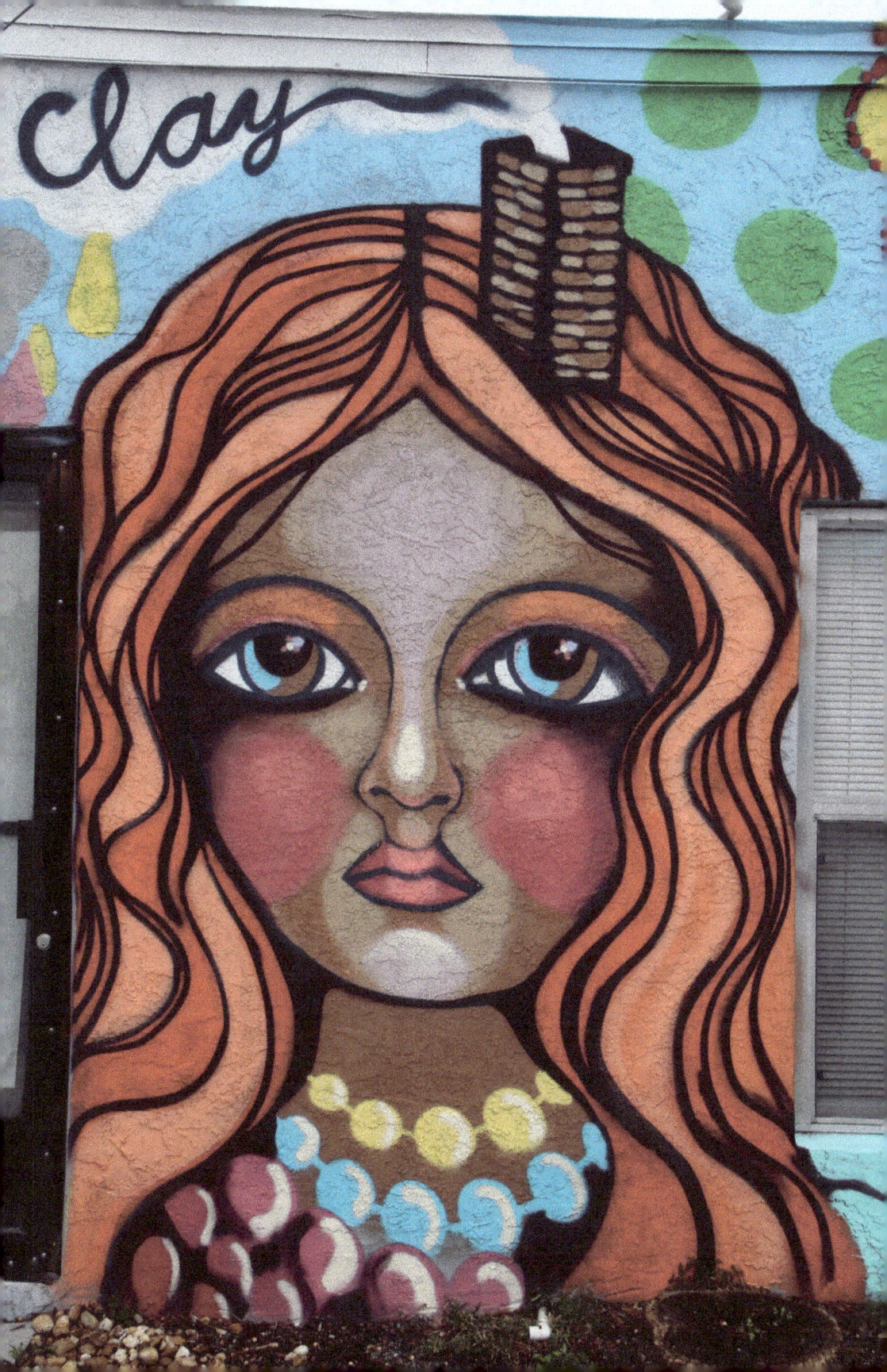

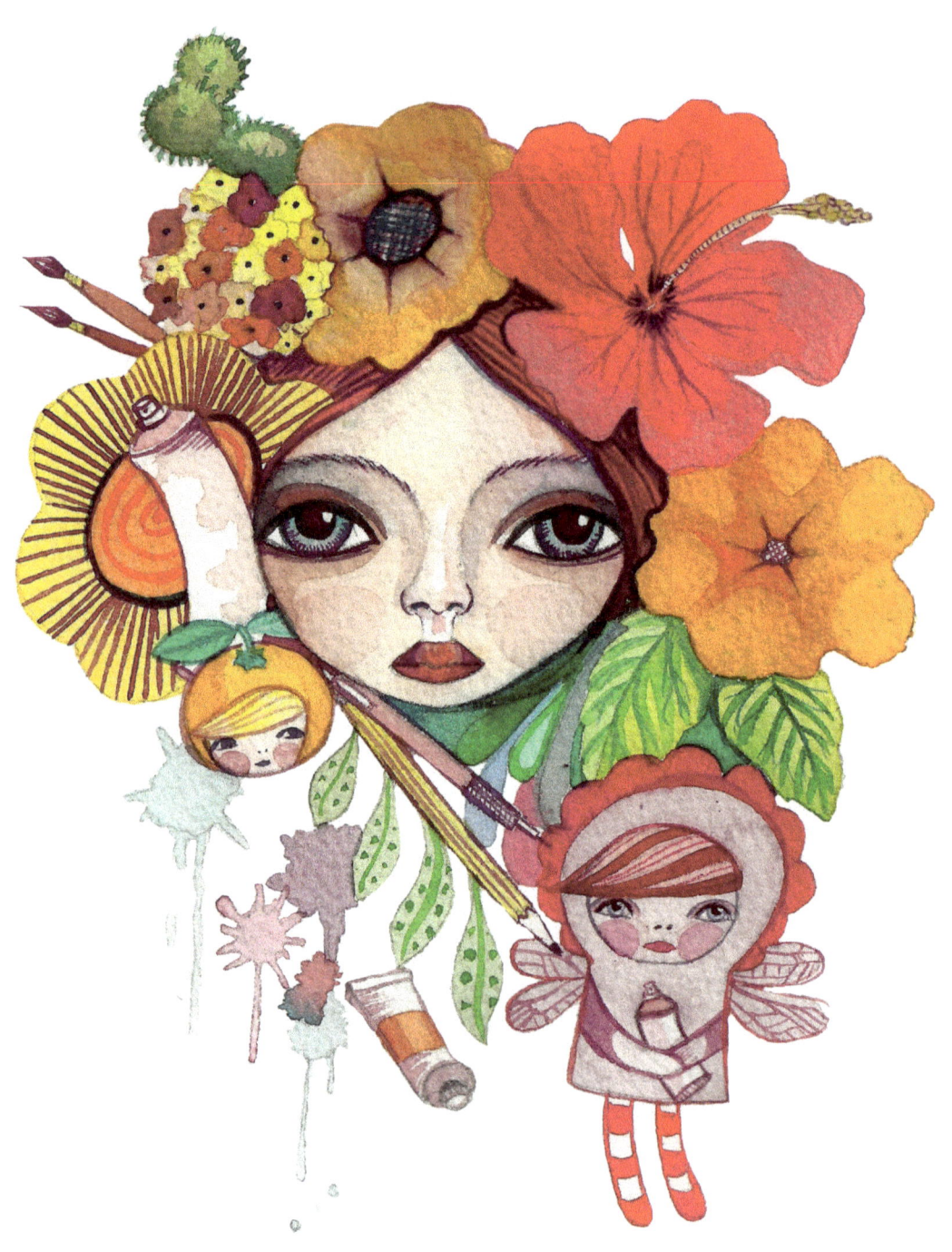

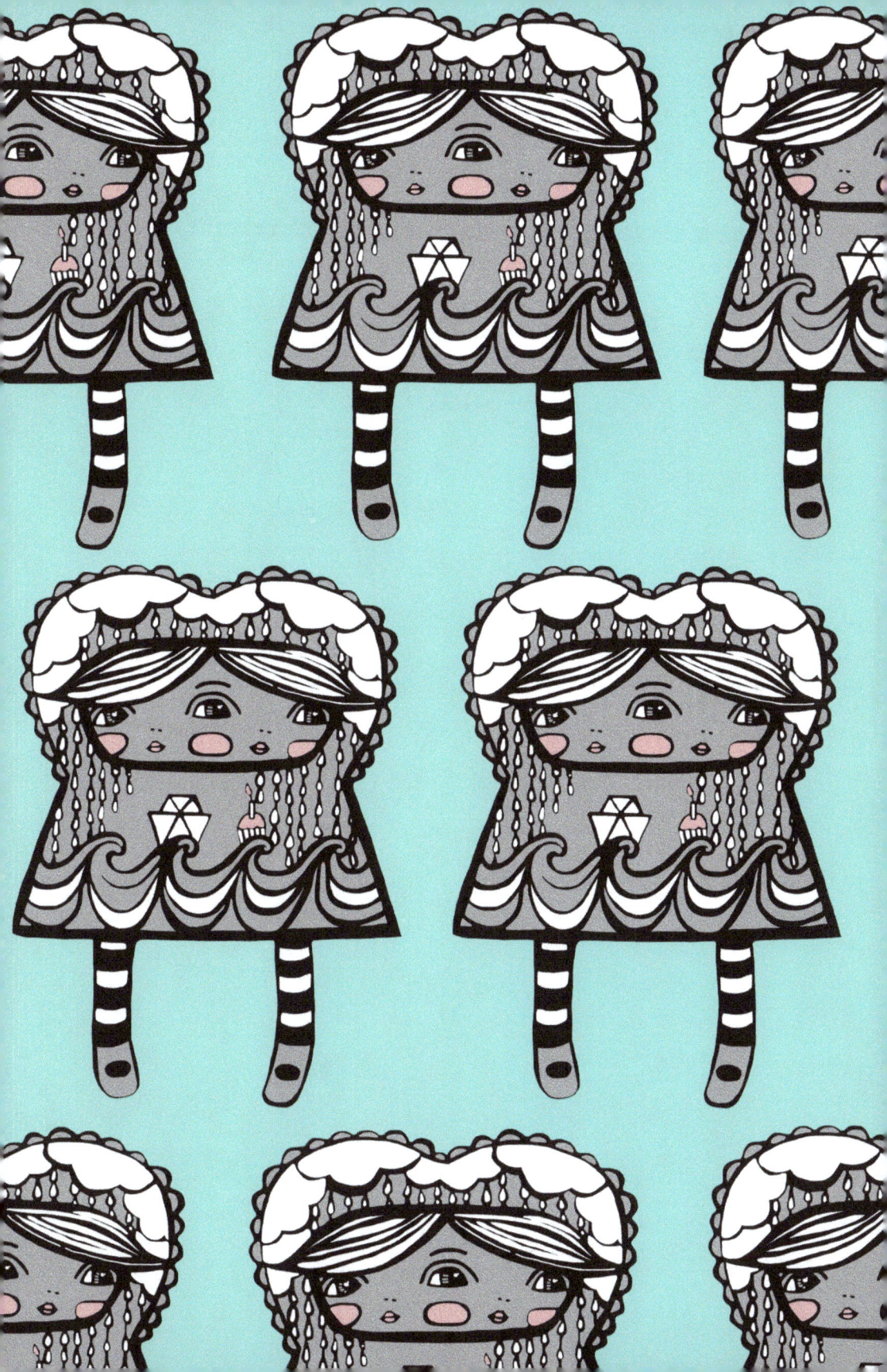

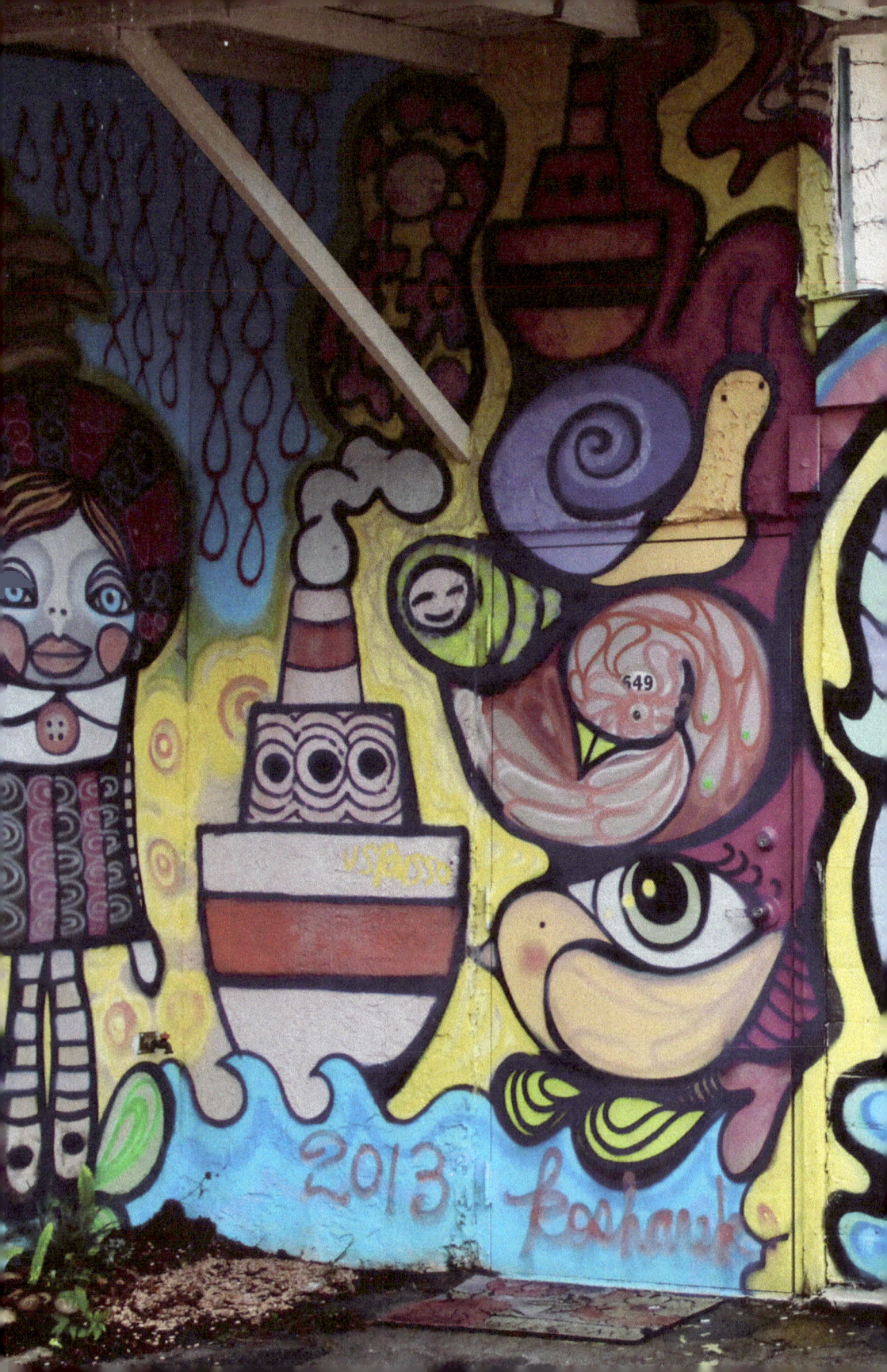

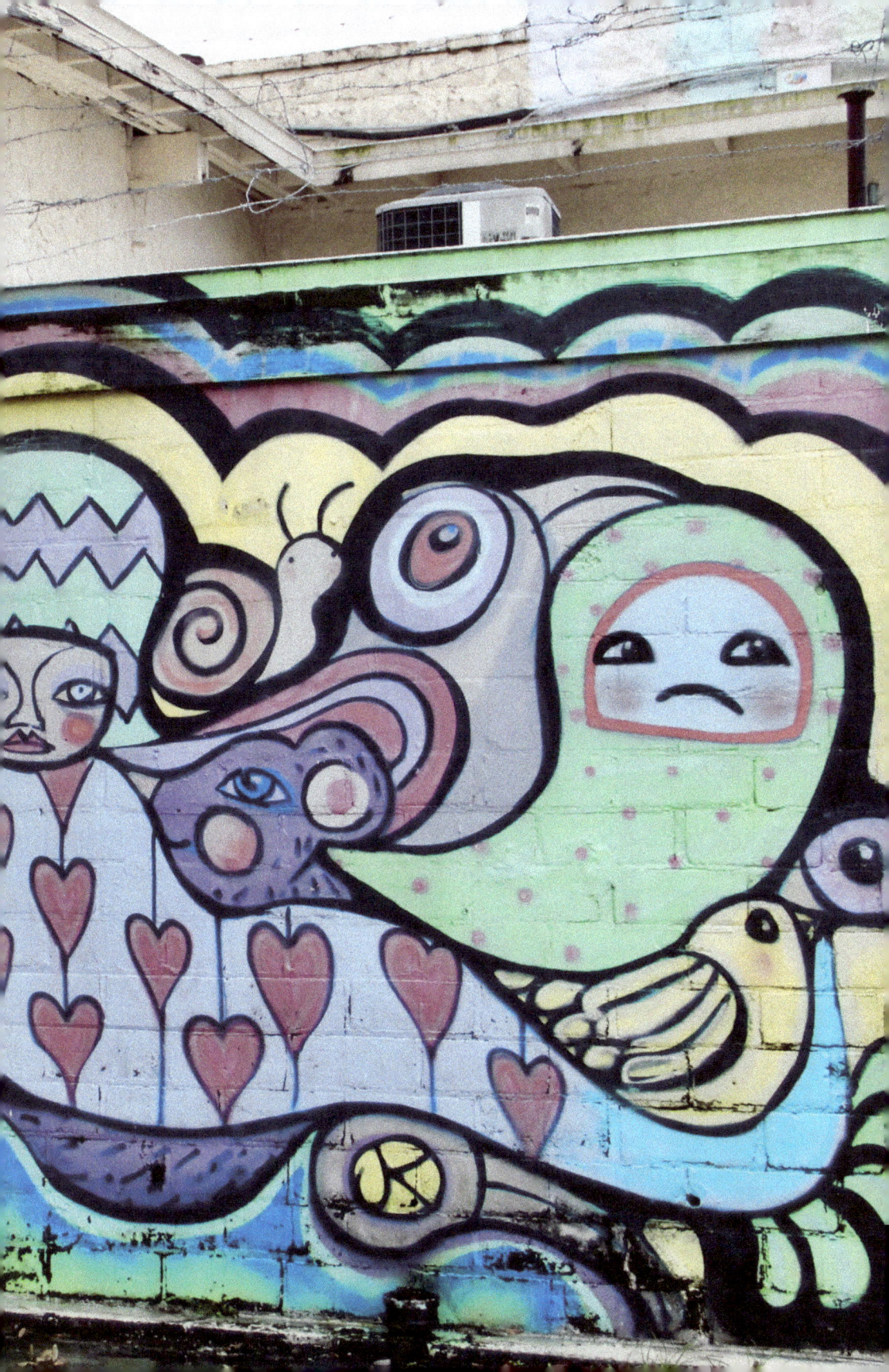

Mural collab by Kosharek
Art & Thirst

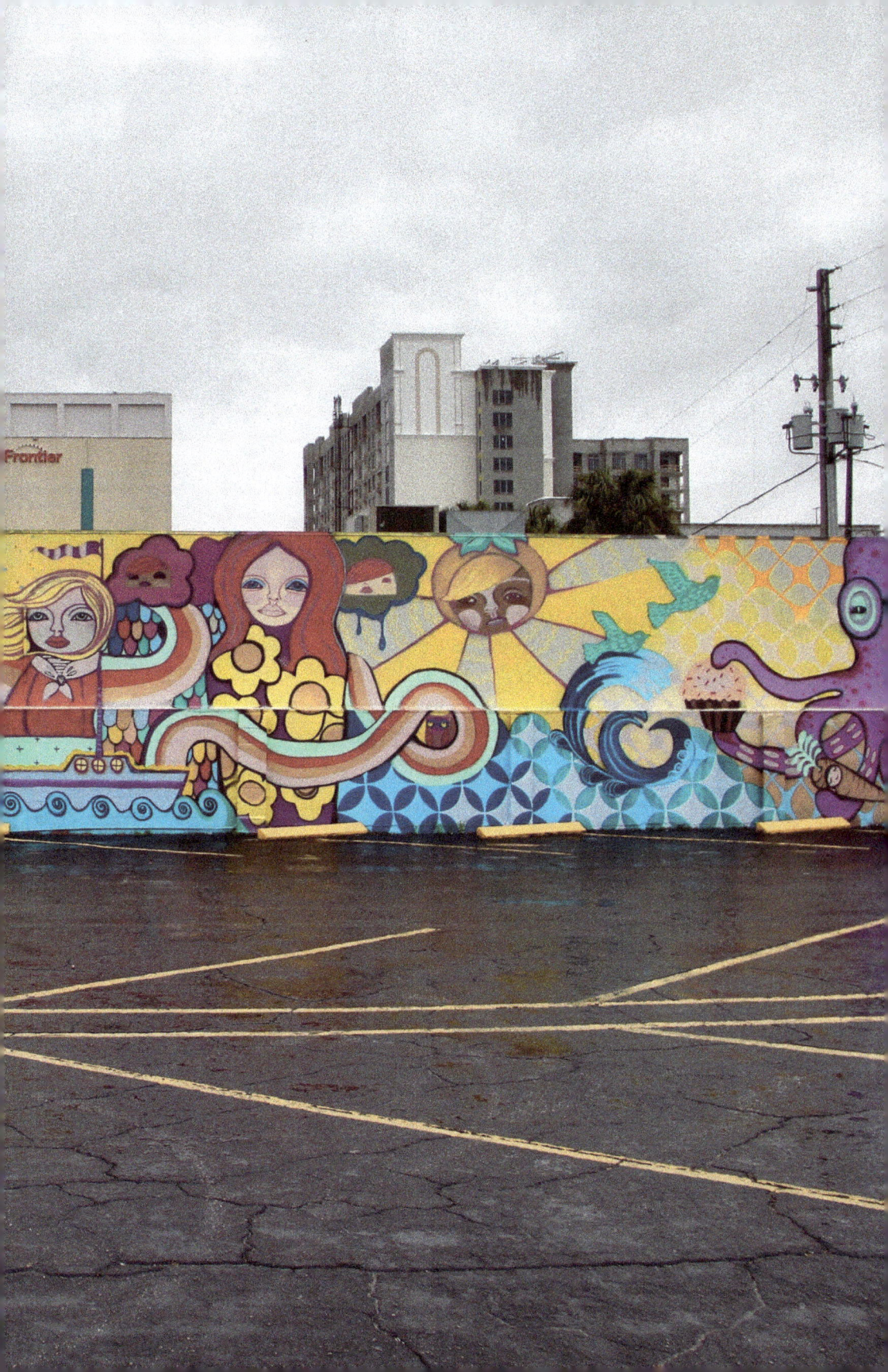

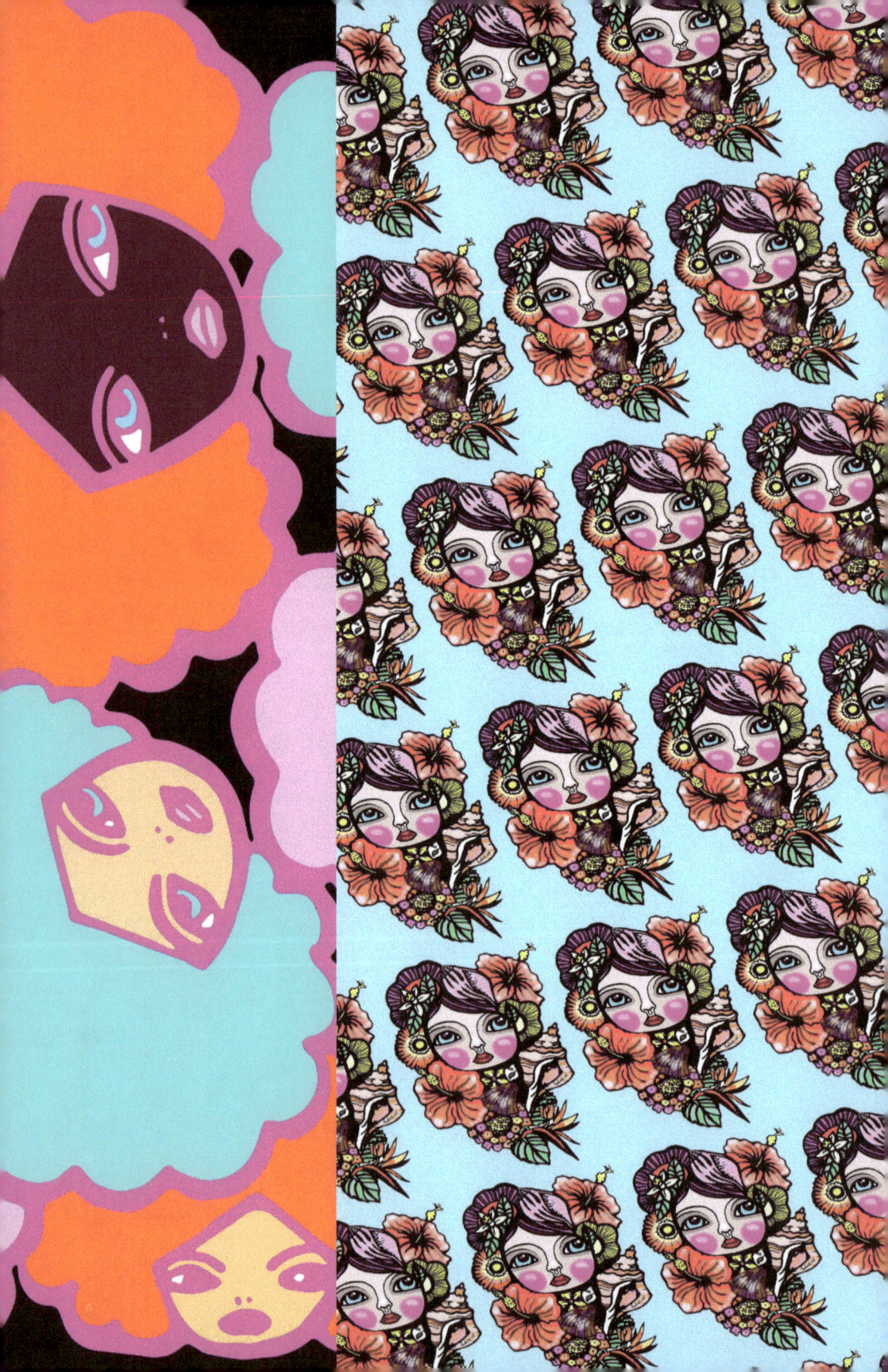

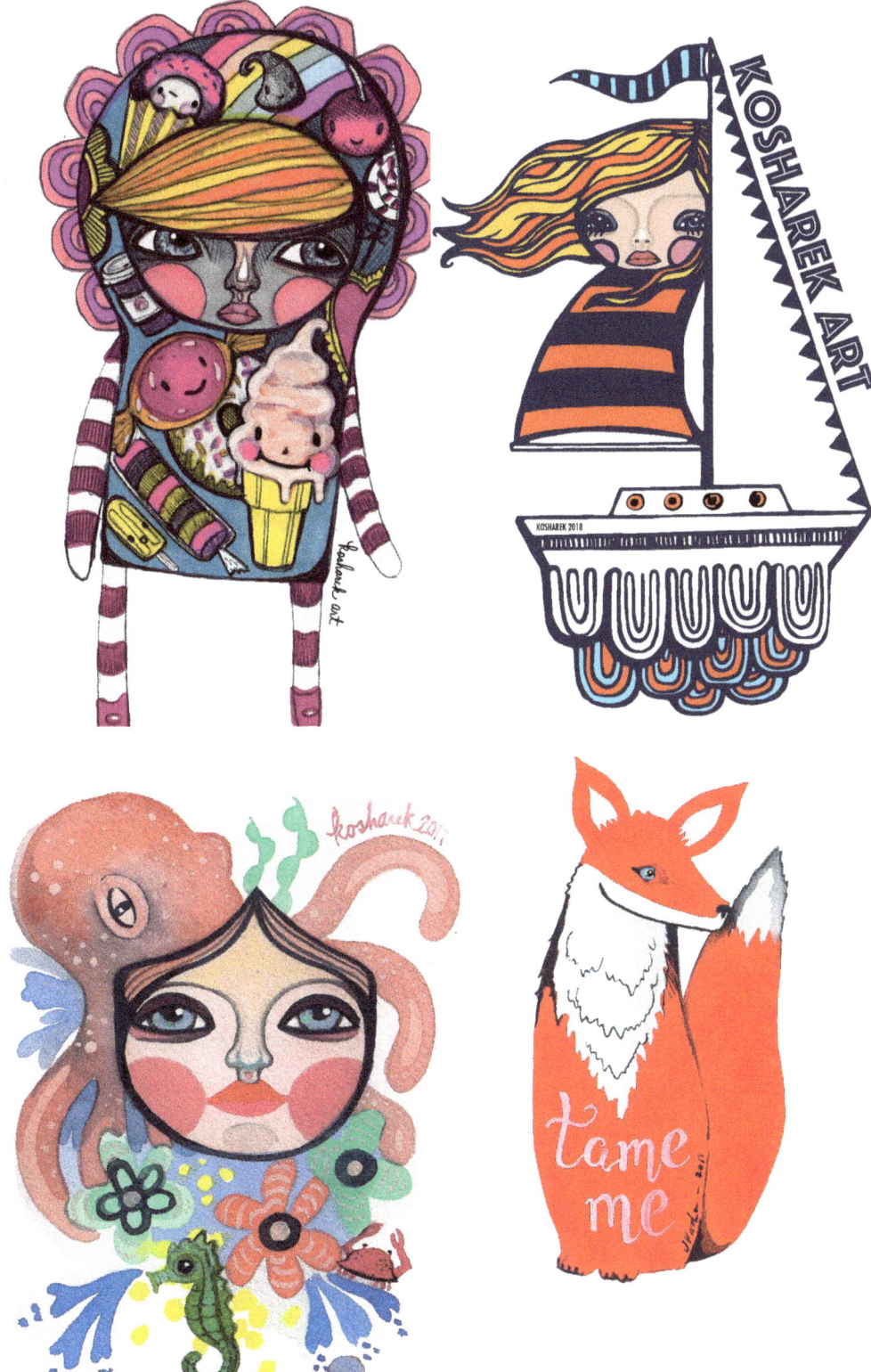

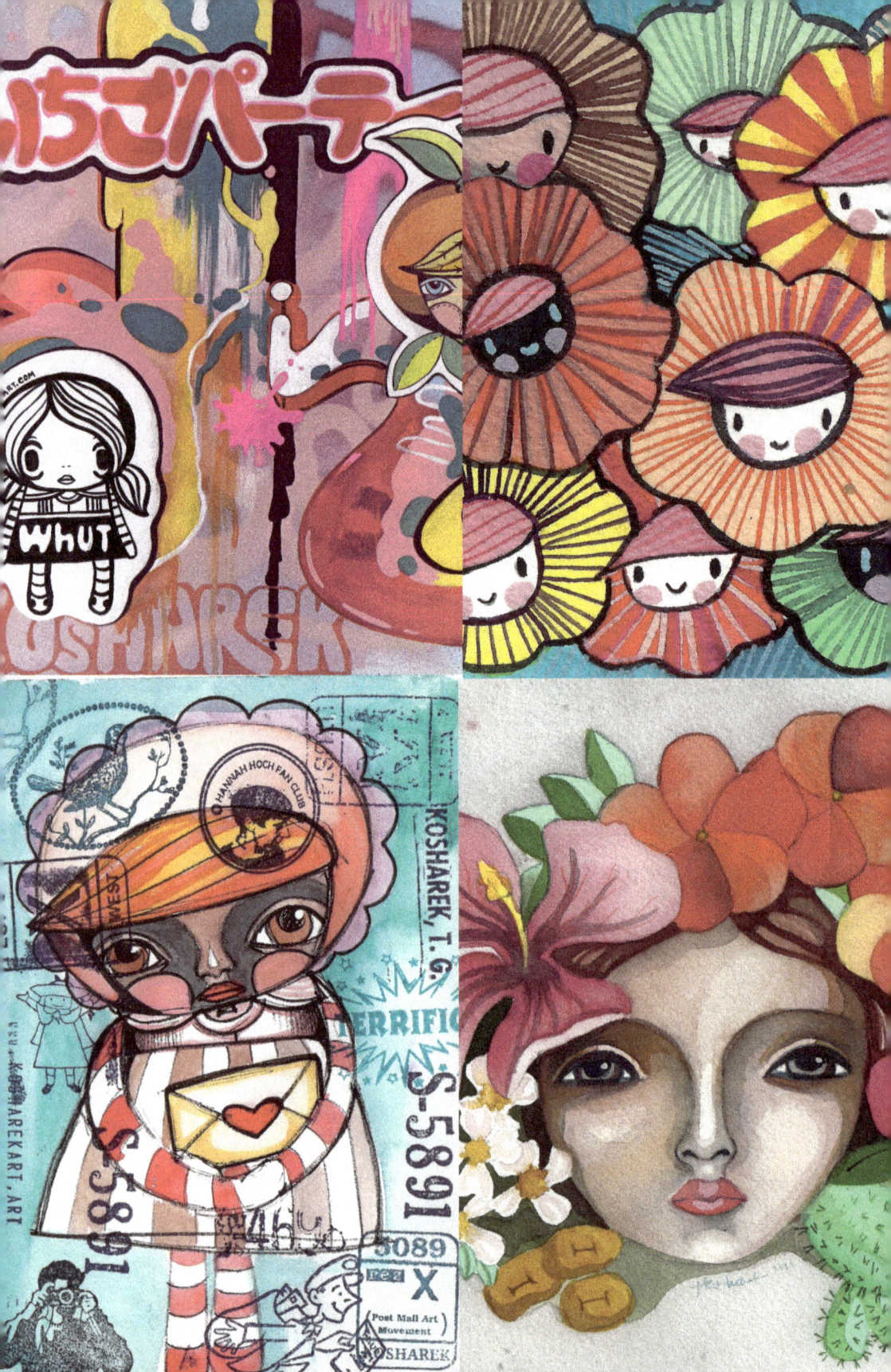

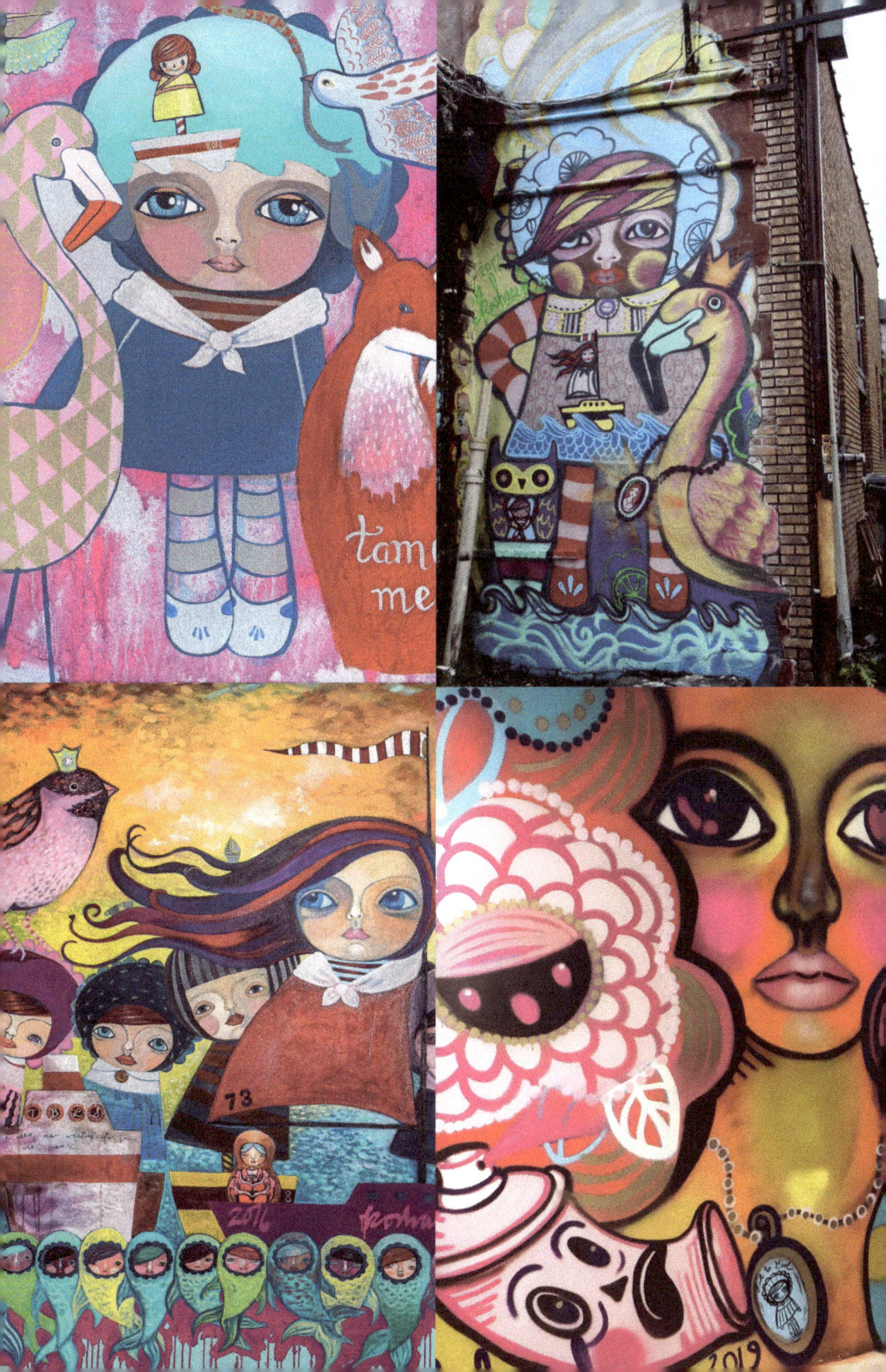

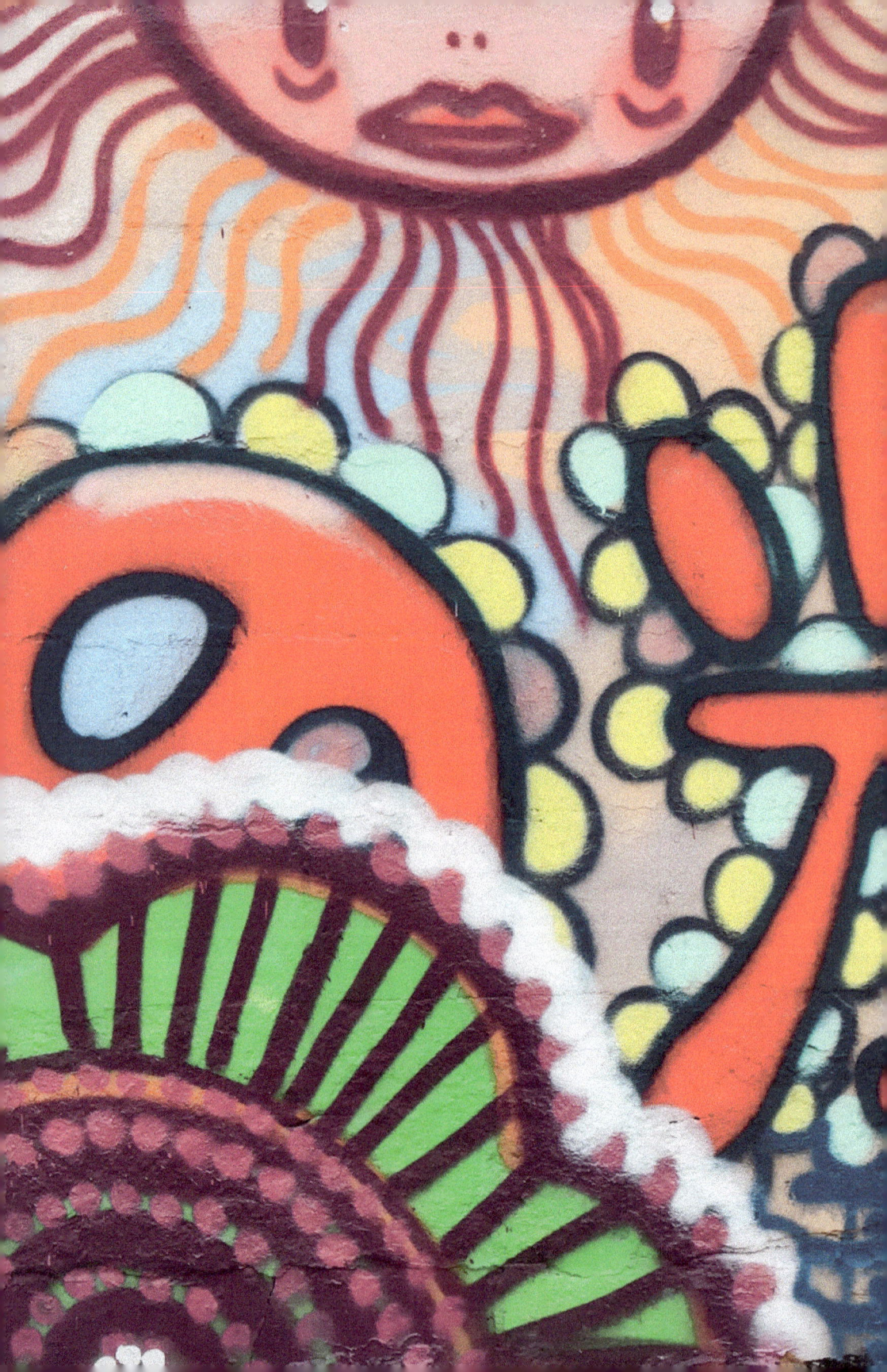

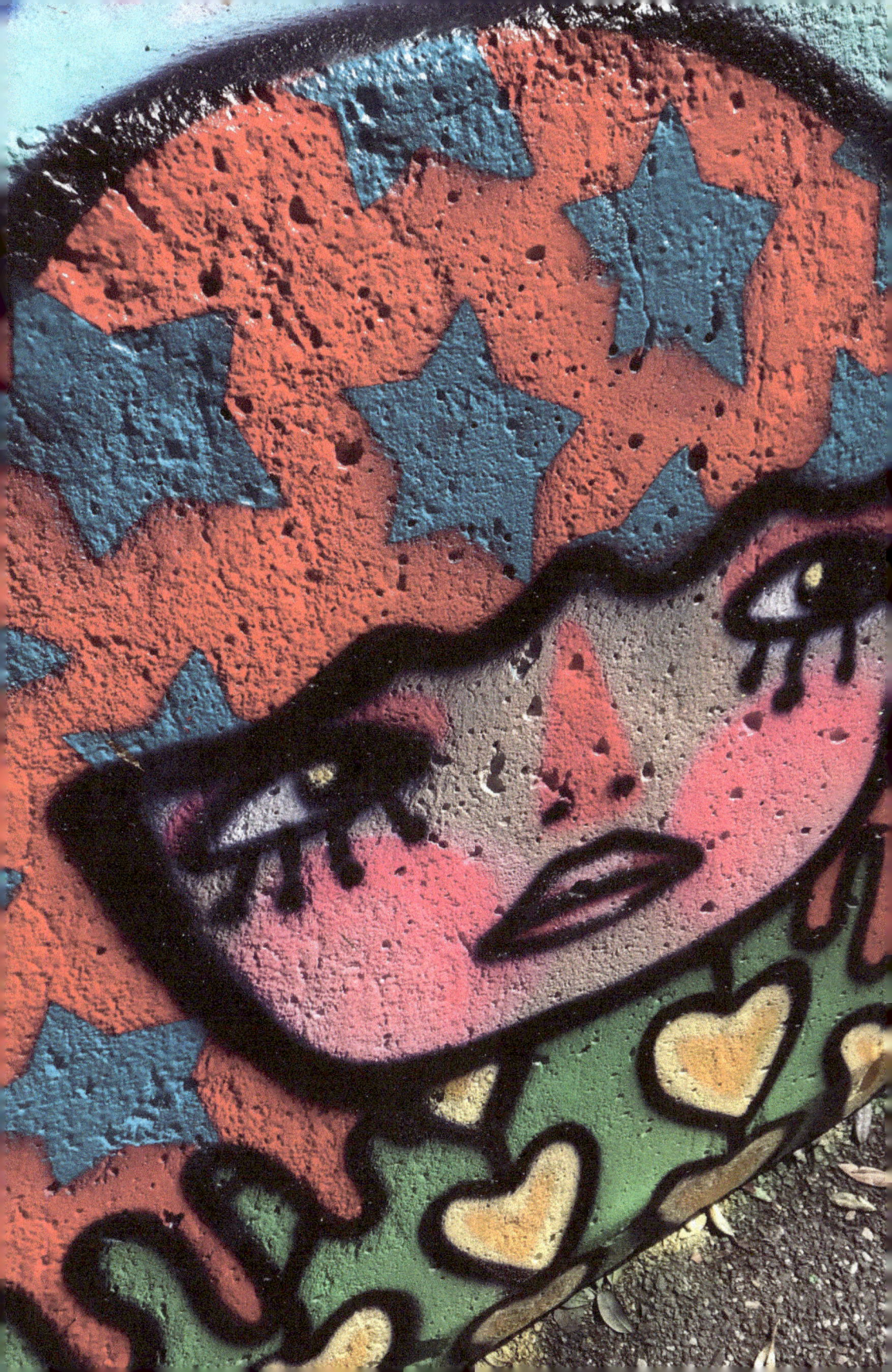

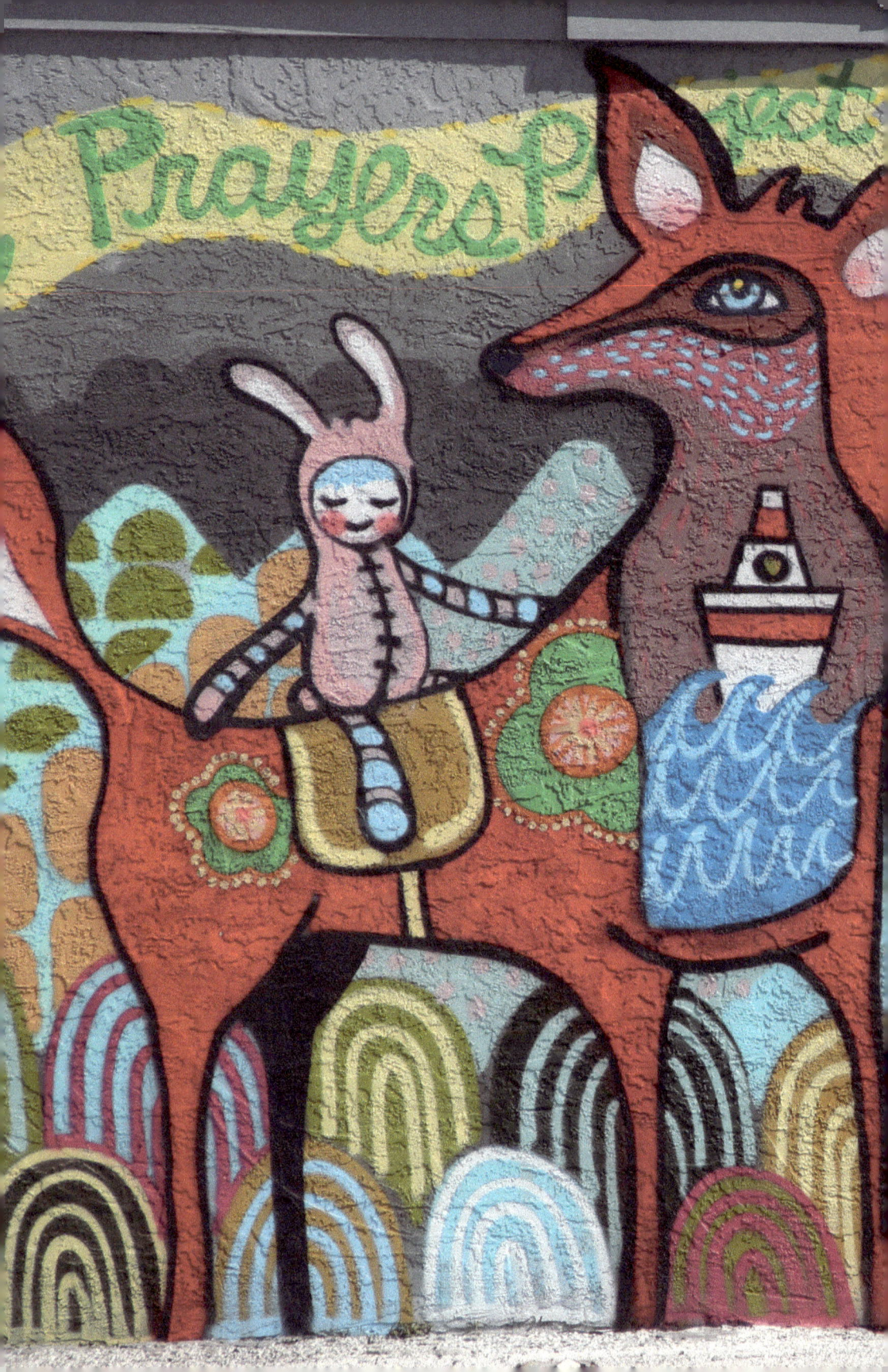

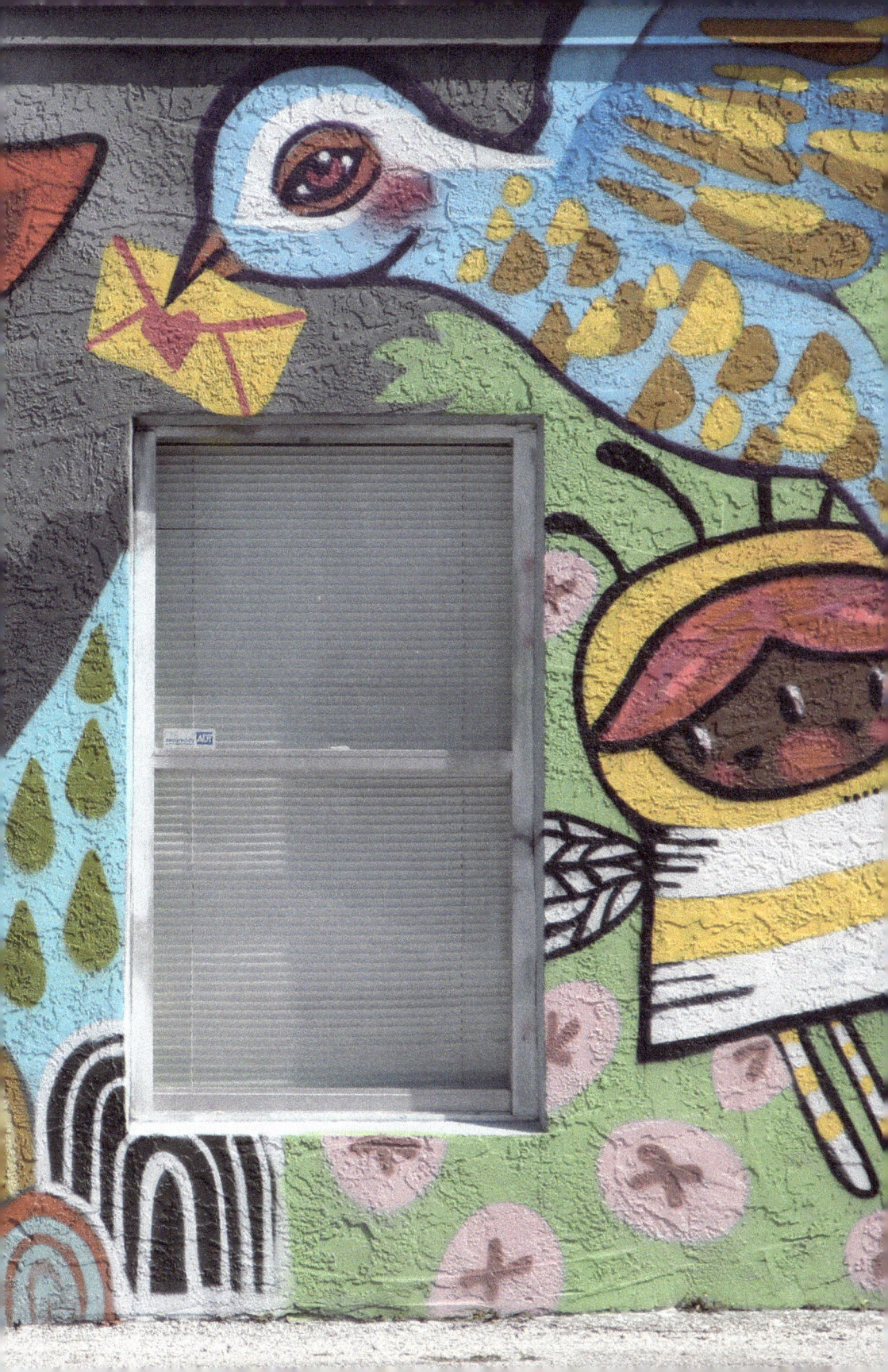

www.ingramcontent.com/pod-product-compliance
Lightning Source LLC
Chambersburg PA
CBHW040110180526
45172CB00009B/1293